RELAXING DOODLES

RELAXING DOODLES

A COLORING BOOK FOR ADULTS

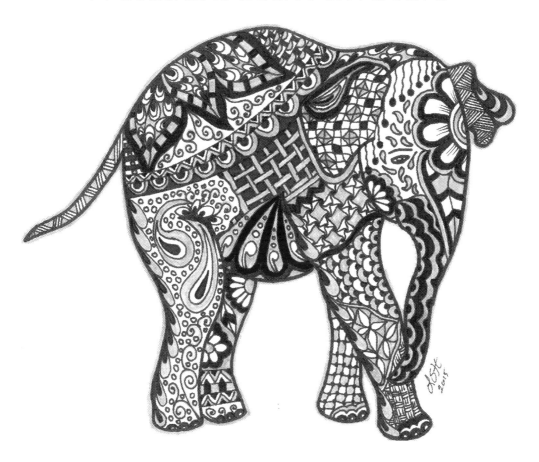

BY LANA SAJAJA

RELAXING DOODLES
A COLORING BOOK FOR ADULTS

iUniverse books may be ordered through booksellers or by contacting:

iUniverse
1663 Liberty Drive
Bloomington, IN 47403
www.iuniverse.com
1-800-Authors (1-800-288-4677)

Because of the dynamic nature of the Internet, any web addresses or links contained in this book may have changed since publication and may no longer be valid. The views expressed in this work are solely those of the author and do not necessarily reflect the views of the publisher, and the publisher hereby disclaims any responsibility for them.

Any people depicted in stock imagery provided by Thinkstock are models, and such images are being used for illustrative purposes only.
Certain stock imagery © Thinkstock.

ISBN: 978-1-4917-7426-7 (sc)
ISBN: 978-1-4917-7427-4 (e)

Library of Congress Control Number: 2015915994

Print information available on the last page.

iUniverse rev. date: 04/04/2016

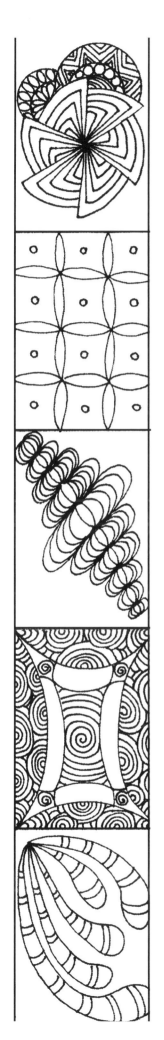

To my wonderful husband. I couldn't have done anything without his encouragement and cooperation and his putting up with me and my crazy artistic ideas for years. Thank you for believing in me, honey.

And to my mom.

Thank you both from the bottom of my heart.

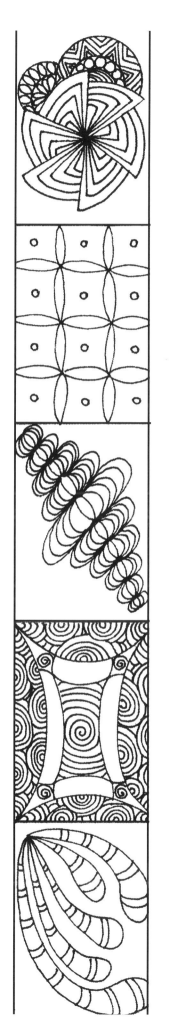

ABOUT THIS BOOK

In this book, you will find forty nine inspiring designs you can have fun and experiment with. I designed my book in a way that you can use each and every drawing just color cut out frame and hang on your walls.

It's very easy, and by the time you finish all the drawings in this book, your house will be filled with beautiful art, with your own touch and color choices that go with your home colors and decor. What a great investment: relaxation and decor. Be proud enjoy looking at the beautiful, vibrant colors, and don't forget to smile.

This book is filled with doodle tangles, the ancient art of mandalas, lettering, geometrical shapes, and Persian paisley designs. **I tried to provide different easy not complicated designs** (I want you to relax while coloring not stress out ☺) art shapes and techniques for you to experiment with. A lot of people use these art forms, but we all see them in different ways and draw them in our own ways. They are based on a repetition of designs drawn from the artist's own perspective.

My influences came from old designs I made in the past, plus nature, fabric designs, rugs, dinnerware, furniture, and my imagination. If you look around you will find these colorful forms of art are everywhere even in ancient sites all around the world.

You can enlarge or reduce the size of any drawing you like (I recommend enlarging and then coloring to have a better color effect on the wall), making different sizes to add more impact to walls.

Give them as gifts to your family, friends, and coworkers for any occasion throughout the year. Help put smiles on people's faces. Spread beautiful colors everywhere, and don't forget to place some on the office walls or on your desk. Every time you get stressed, take a look at the vibrant colors you made. I'm sure they will bring a smile to your face, and maybe you'll be excited to get home and color more.

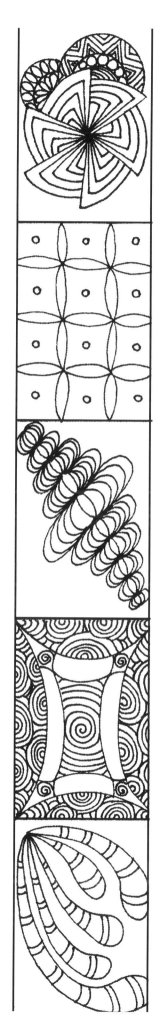

HOW TO USE THIS BOOK

Coloring is known to calm nerves and ease stress. It takes us back to our childhood years when we had no worries and the world was filled with beautiful dreams, hopes, rainbows, and colored Popsicles.

To color this book, I recommend that you use the following:

- colored pencils
- Sharpies (or any permanent markers)
- Copic markers or Prisamacolor brush tips
- watercolors
- watercolor pencils and a water color brush

I do not recommend crayons, because they have thicker tips. I personally prefer permanent markers like Sharpies because they have bold colors that look beautiful and vibrant once you frame the art and hang it on the wall. You can also use their pastel colors to make soft hues.

Don't stress out if the first drawing doesn't come out the way you want it. Experiment. There are forty nine drawings to help you improve your coloring skills. Start with the easiest drawing I included a few easy-to-start-with drawings. Then go with the more complicated ones.

Imagine a beautiful spring garden with lots of colorful flowers and greenery. Have fun.

Always remember this coloring book is for your own enjoinment and relaxation. There are no deadlines, no boss pushing you, and no competition. Trust me—you will discover a great artist inside of you, screaming to come out.

Grab this book, your colored pencils or markers, and a nice cup of milk or hot chocolate. Find a relaxing spot in your house, and go for it. Fill your world with colors of joy. Then don't hesitate to hang your artwork in every room of the house.

I hope that you will enjoy it to the max. Good luck.

Please tell me your opinions. Log on to my Facebook page, www. facebook.com/relaxingdoodles or e-mail me at relaxingdoodles@ yahoo.com and share with me what you did. I look forward to seeing your finished art. And if you have any questions regarding coloring techniques, I'm here to help.

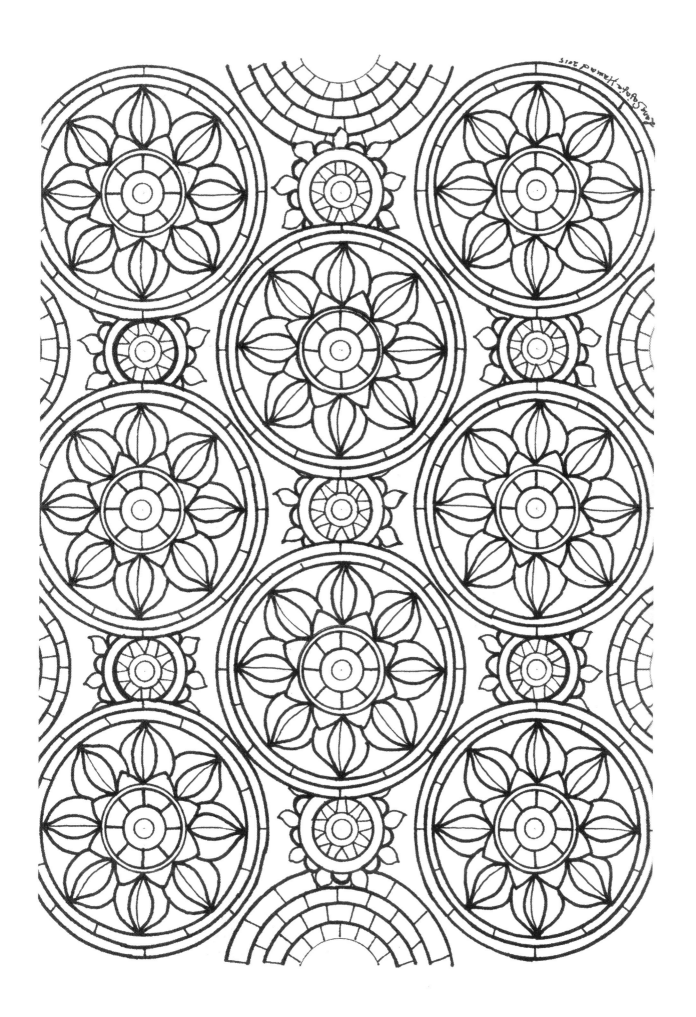

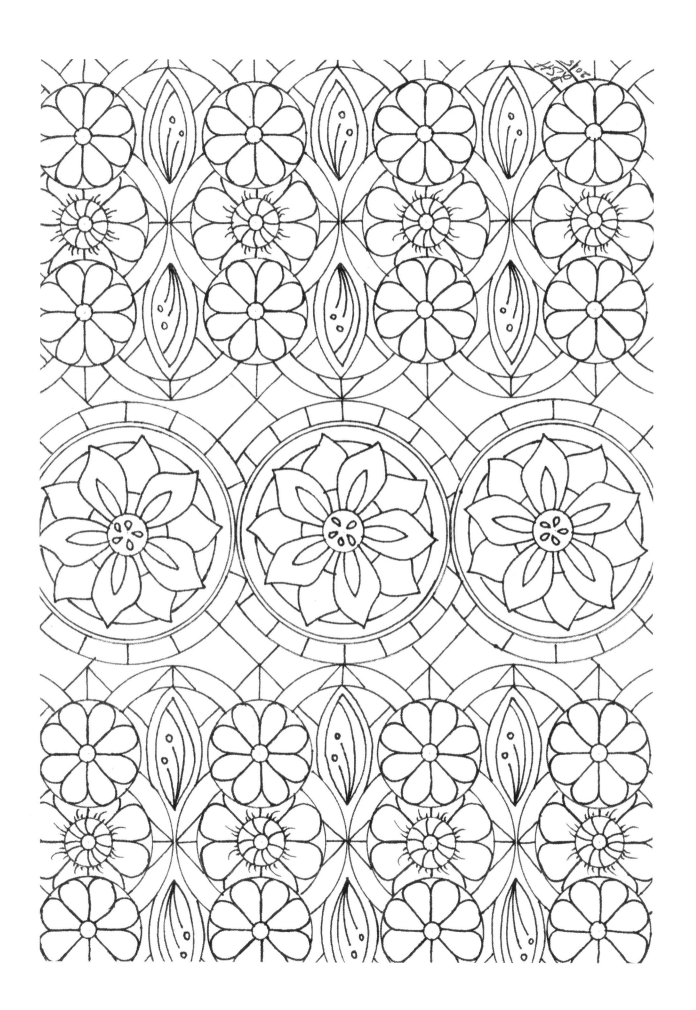

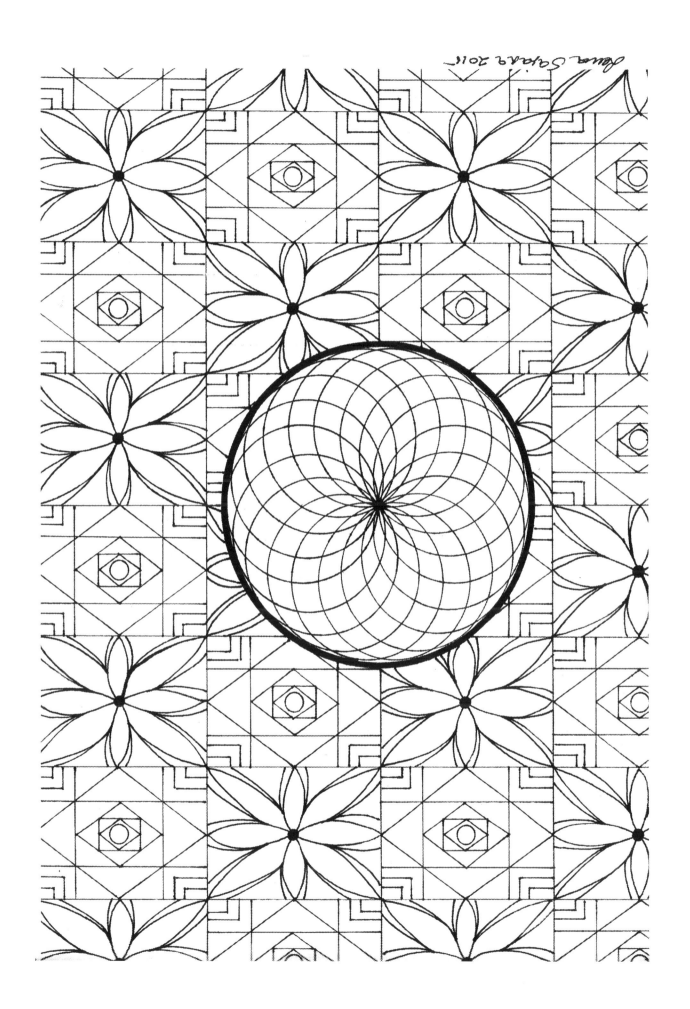

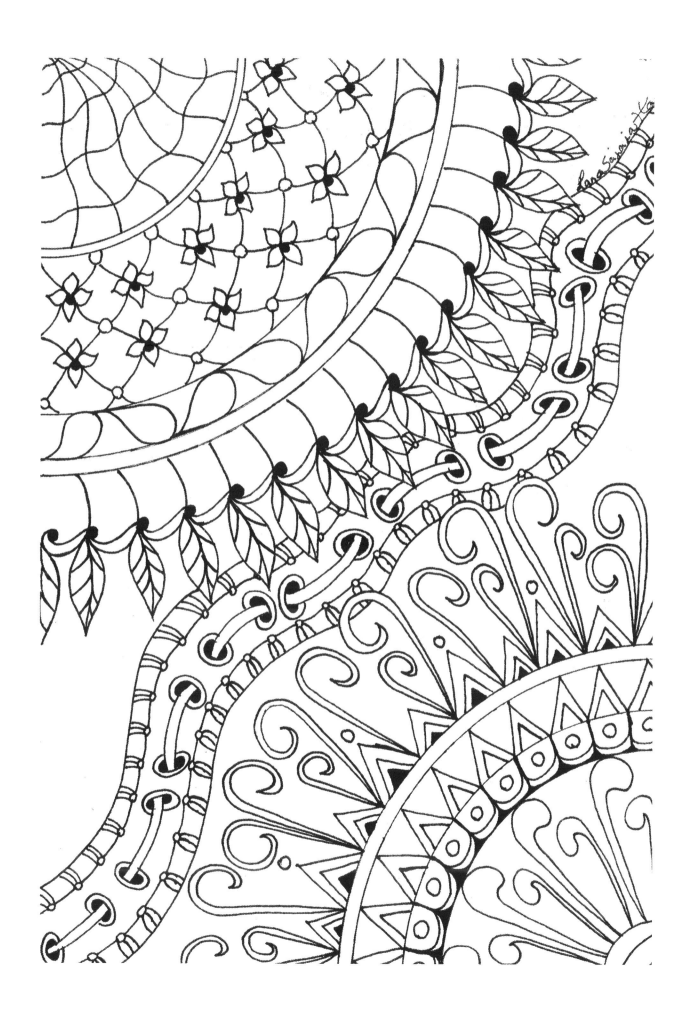

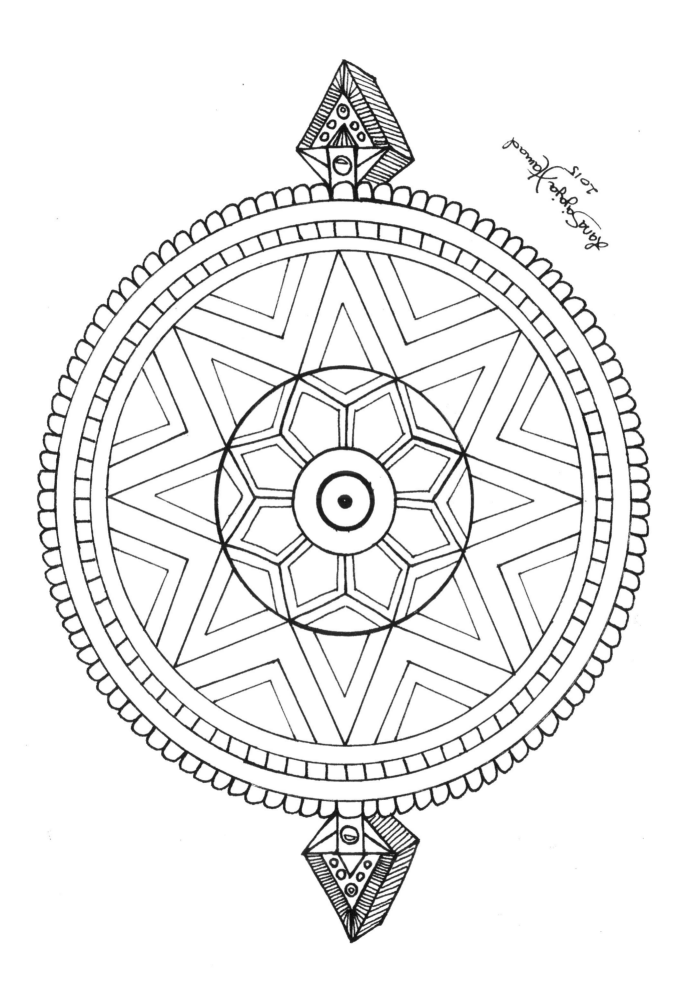

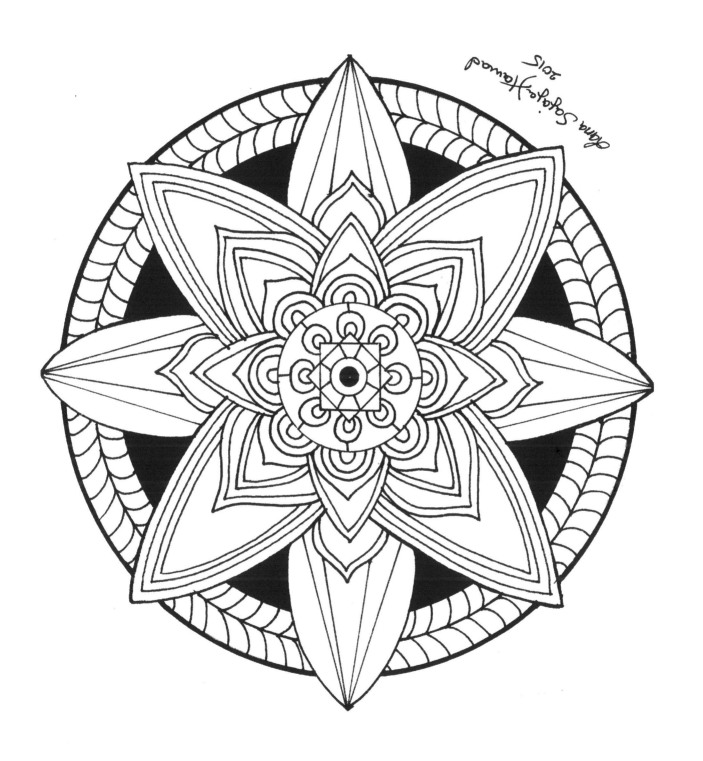

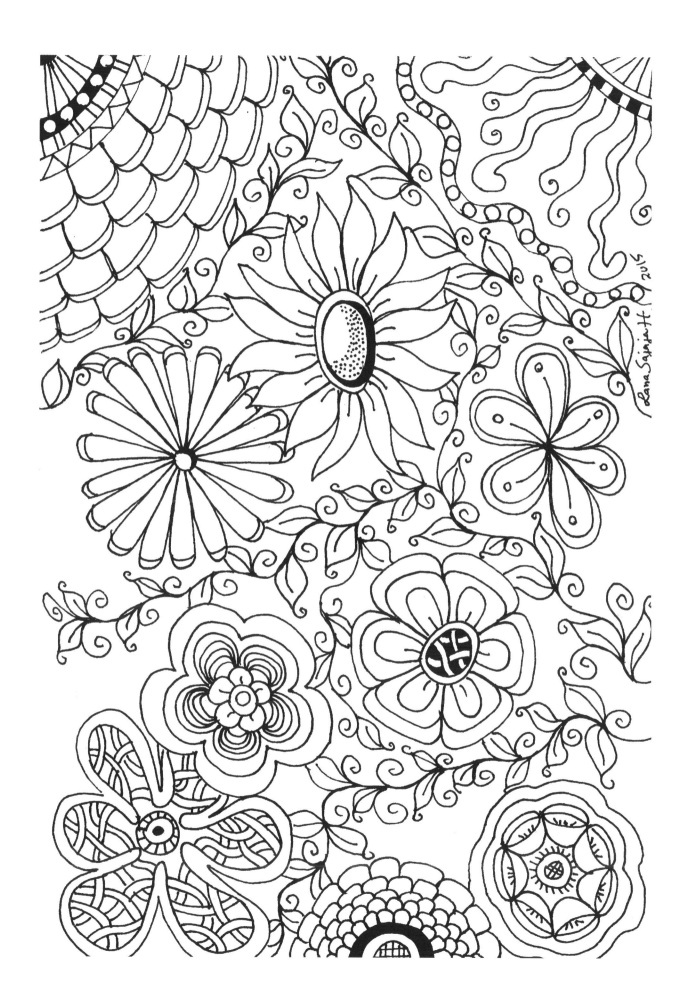

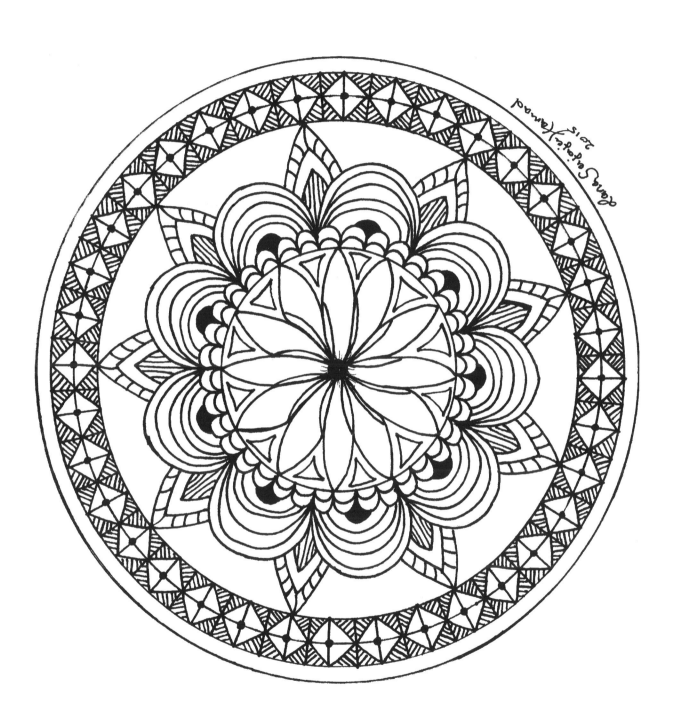

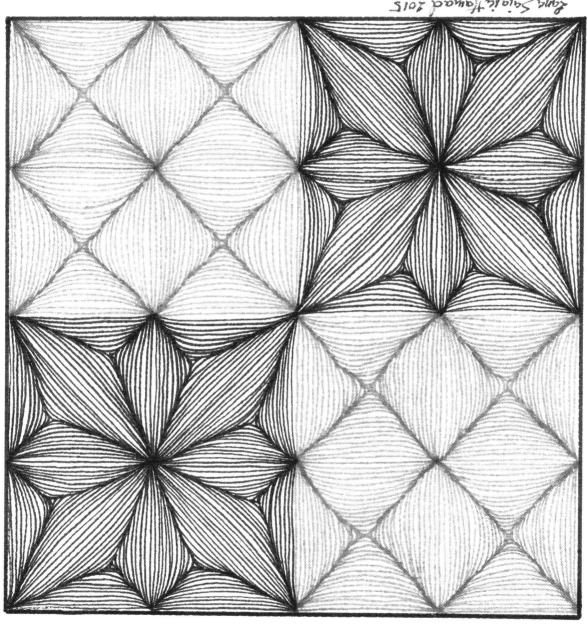

Zana Sajja Hawad 2015

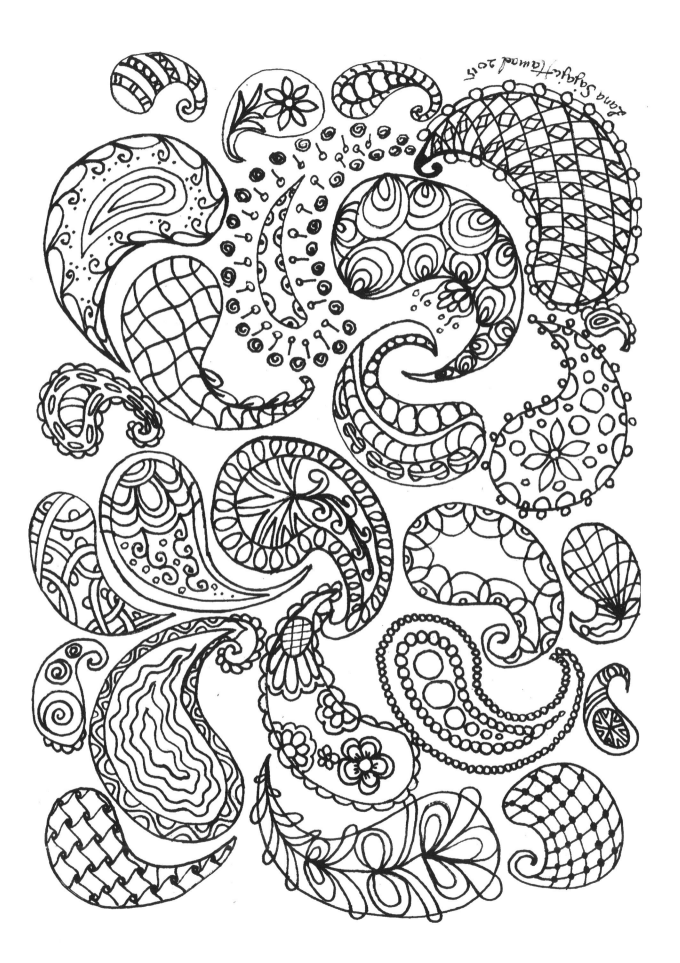

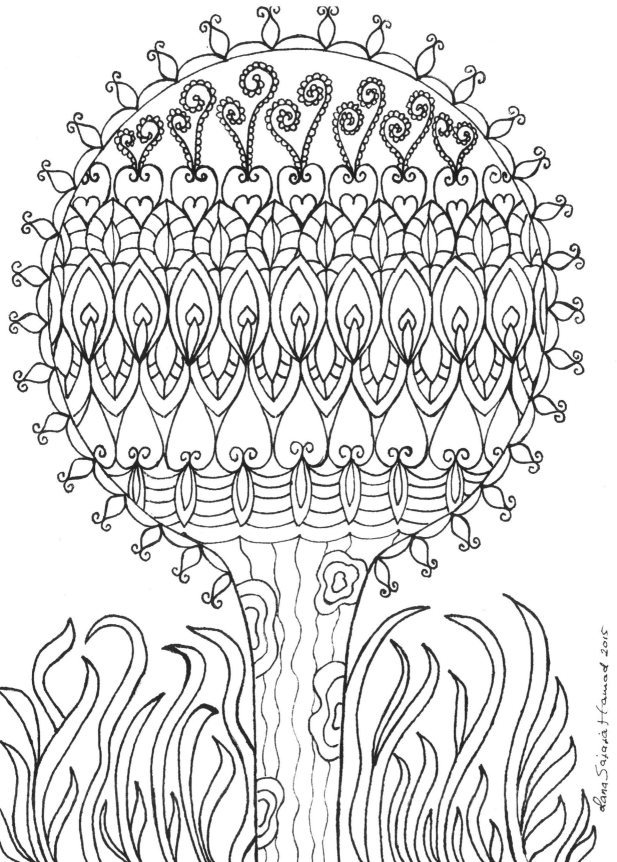

Lana Sajara Hamad 2015

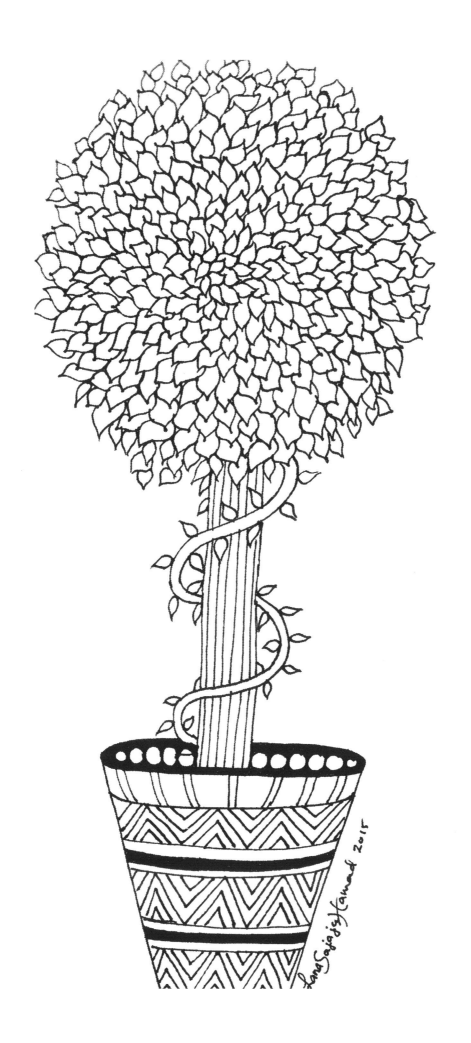

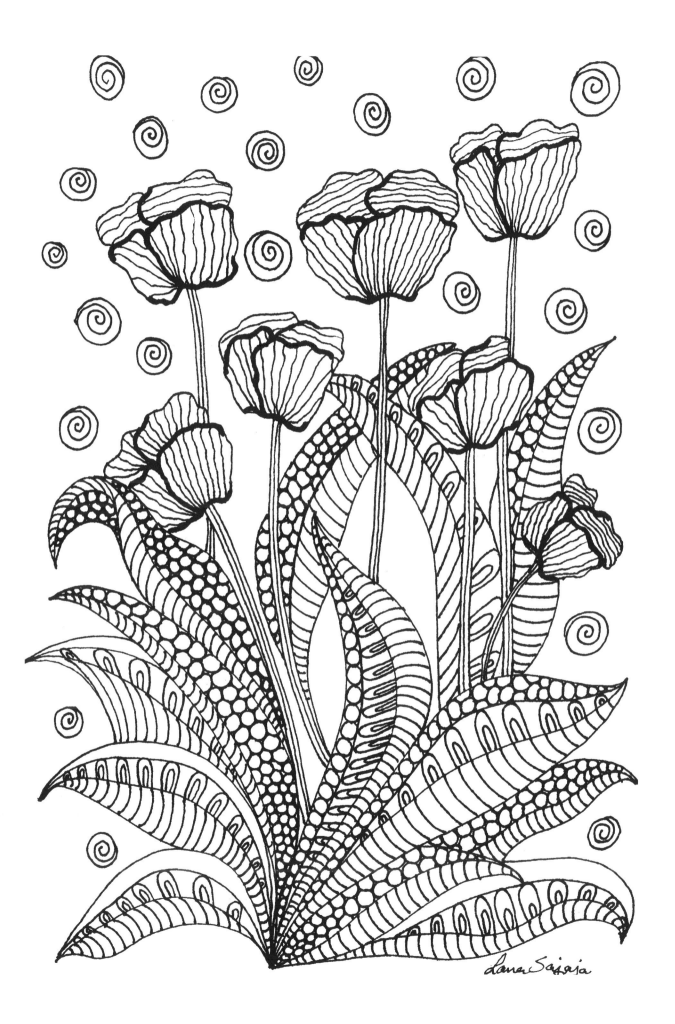

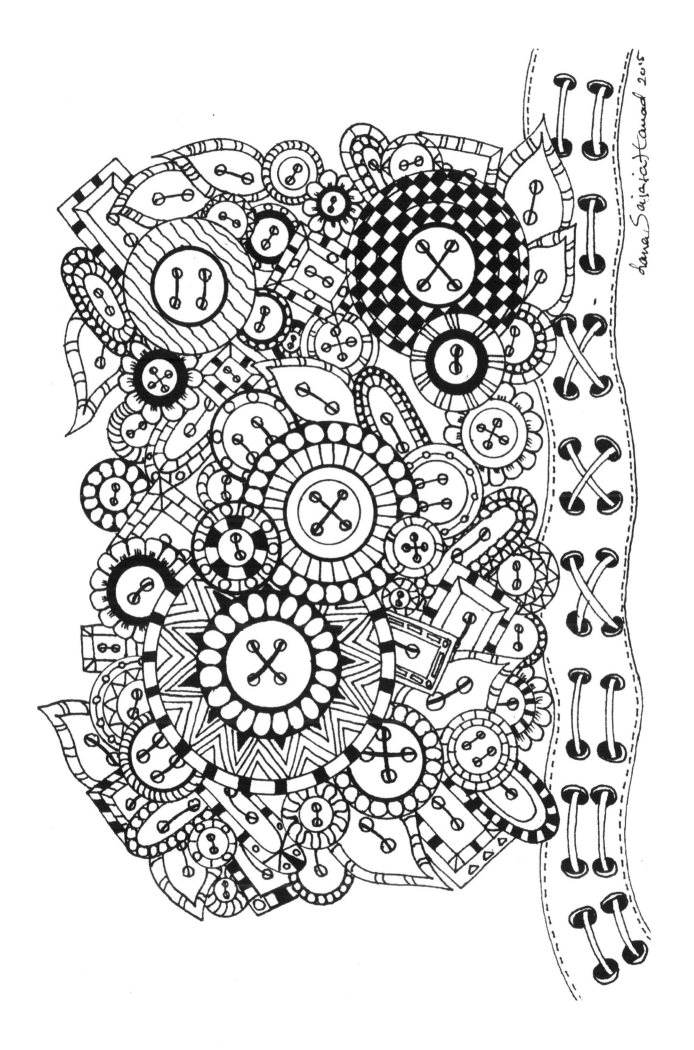

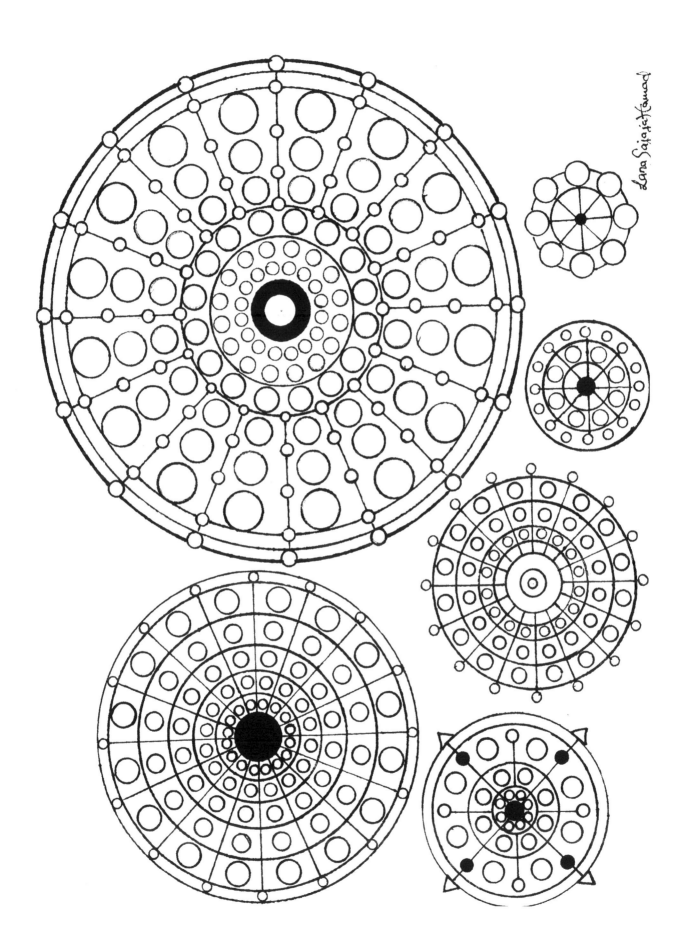

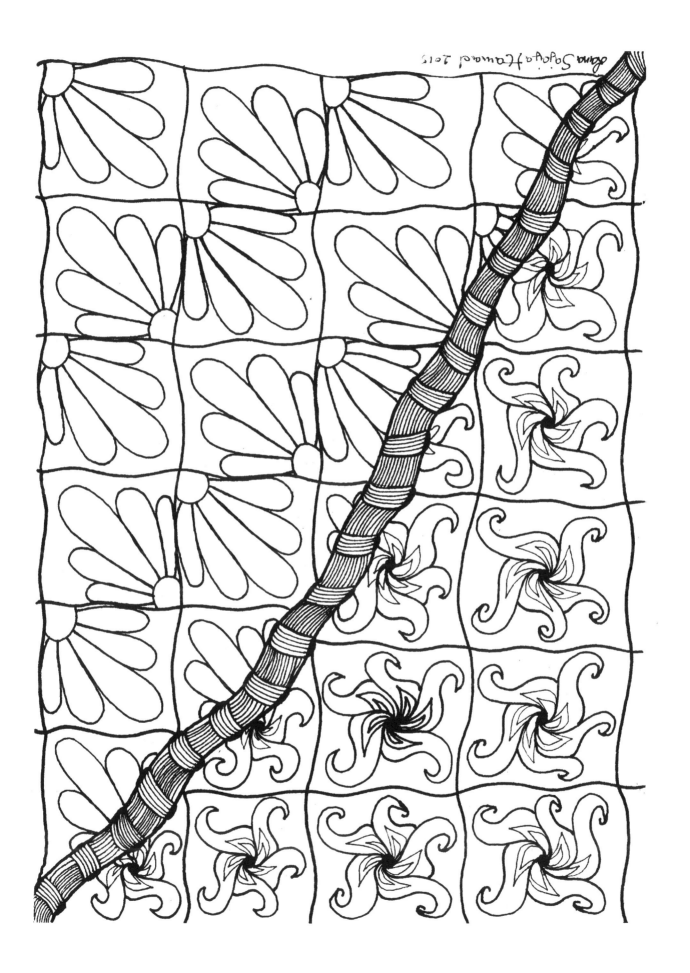

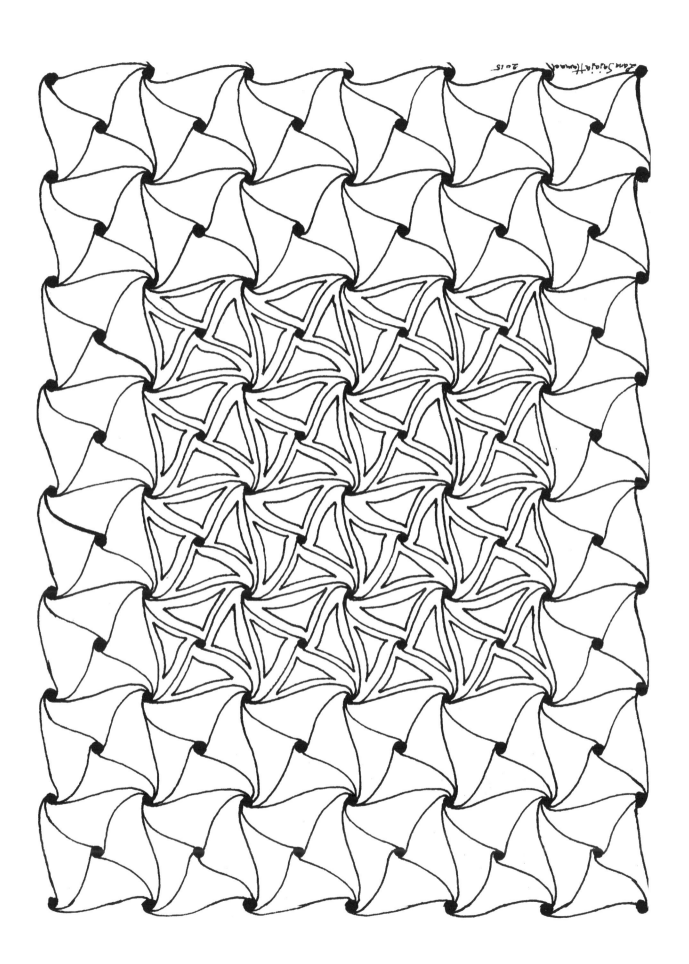

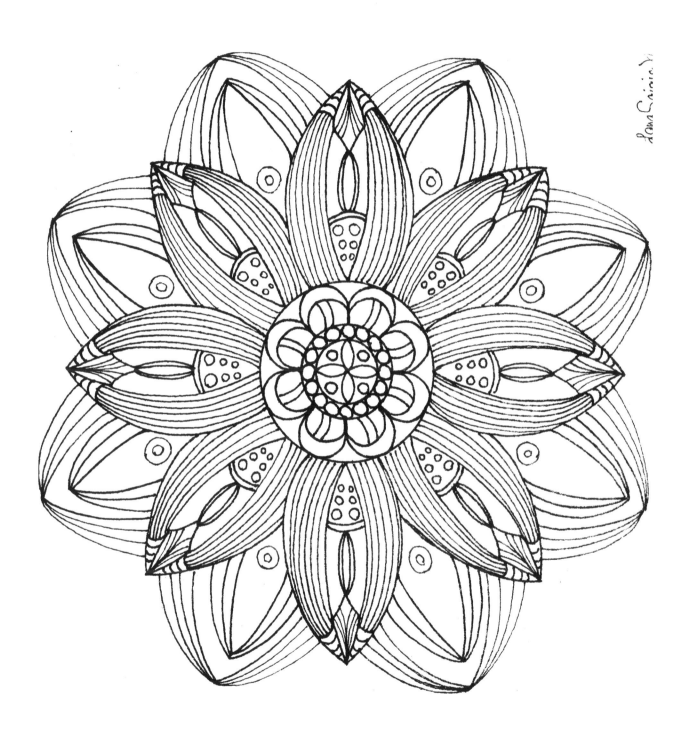

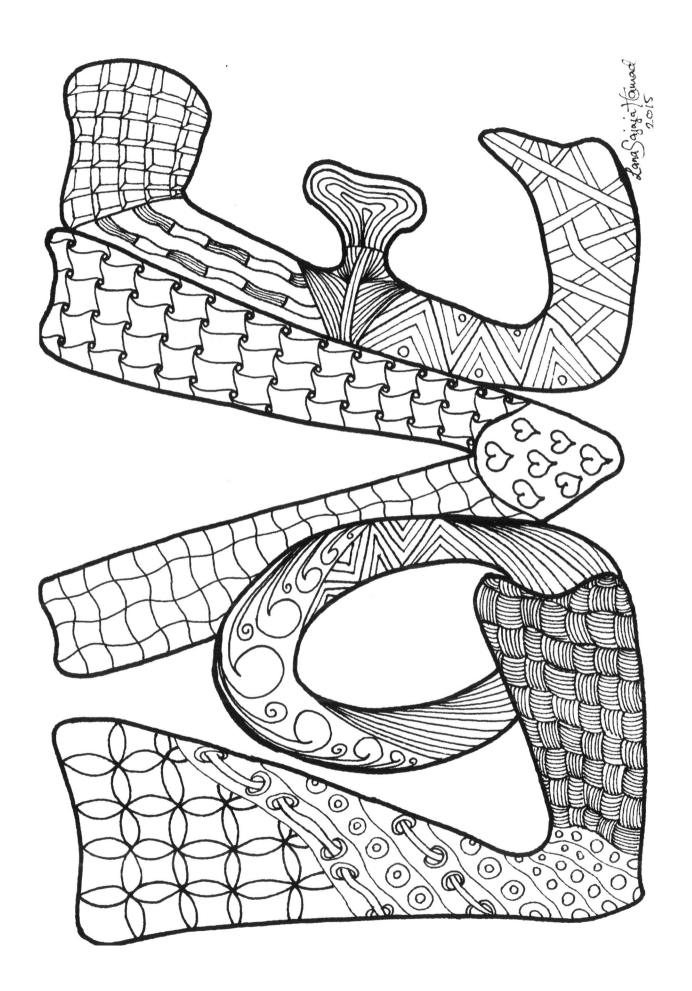

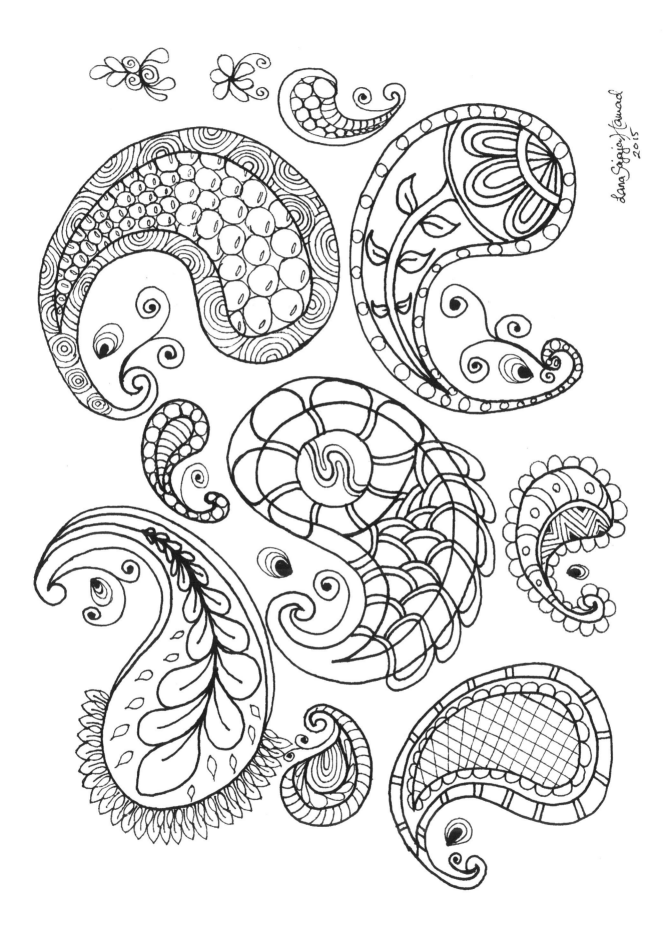

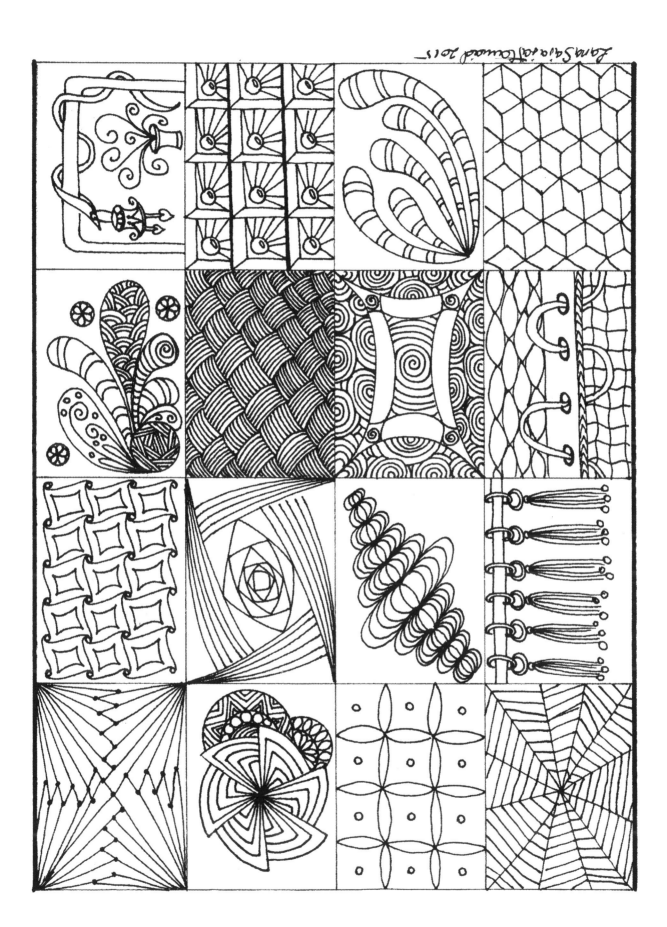

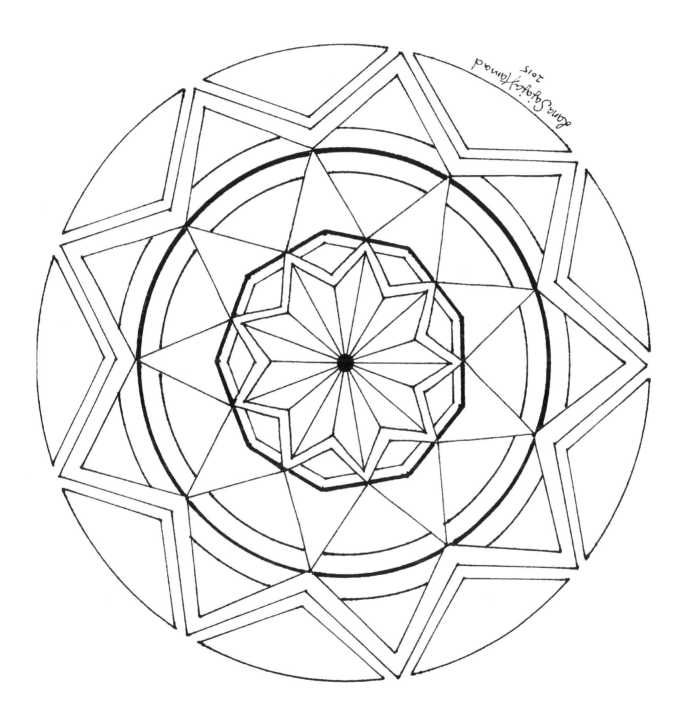

Dana Sajaj Hamad 2015

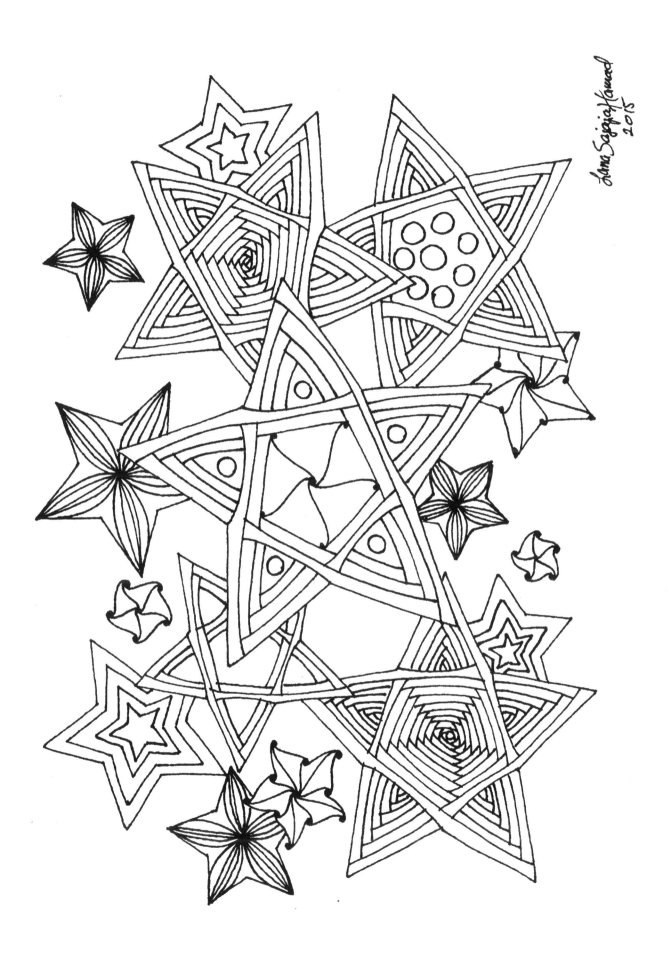

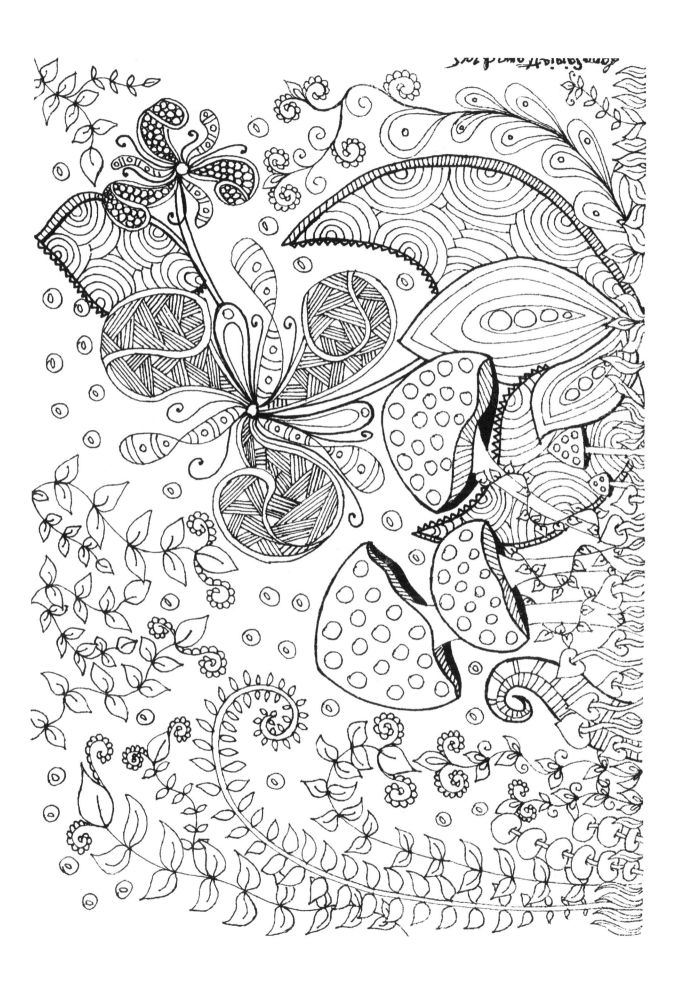

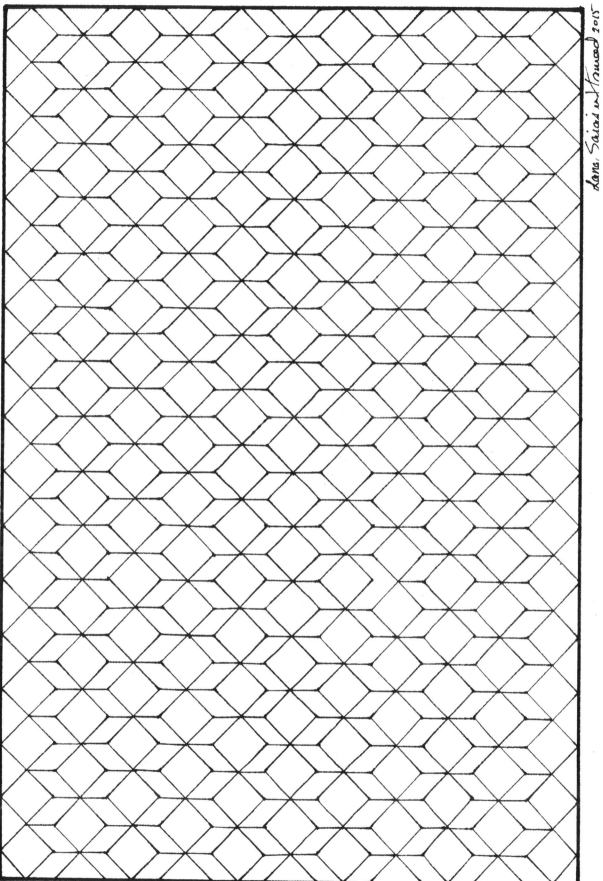

Lana Saiad and Hamad 2018

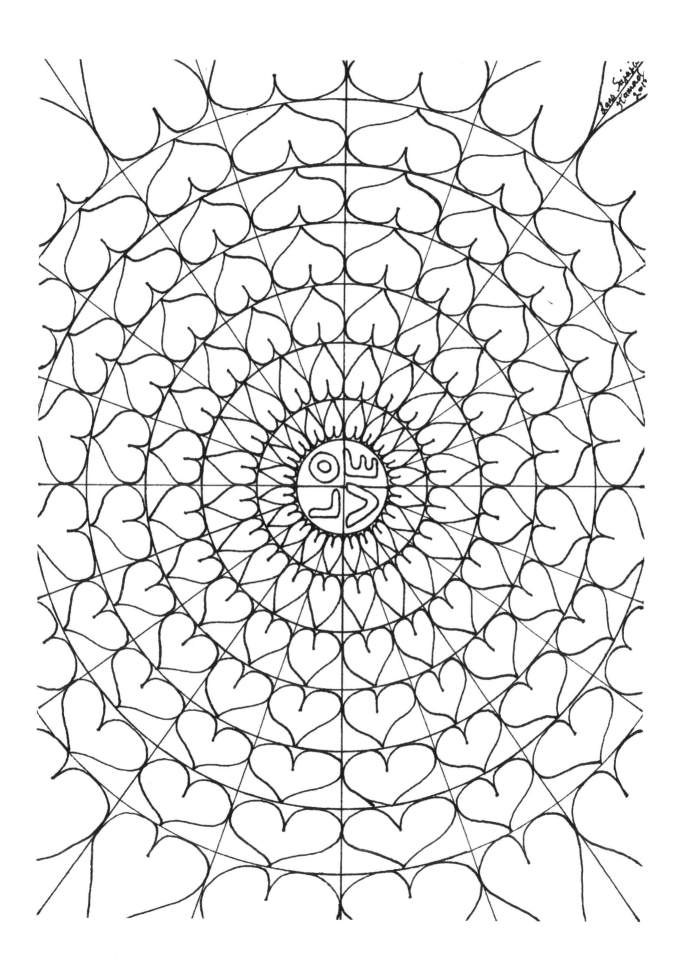

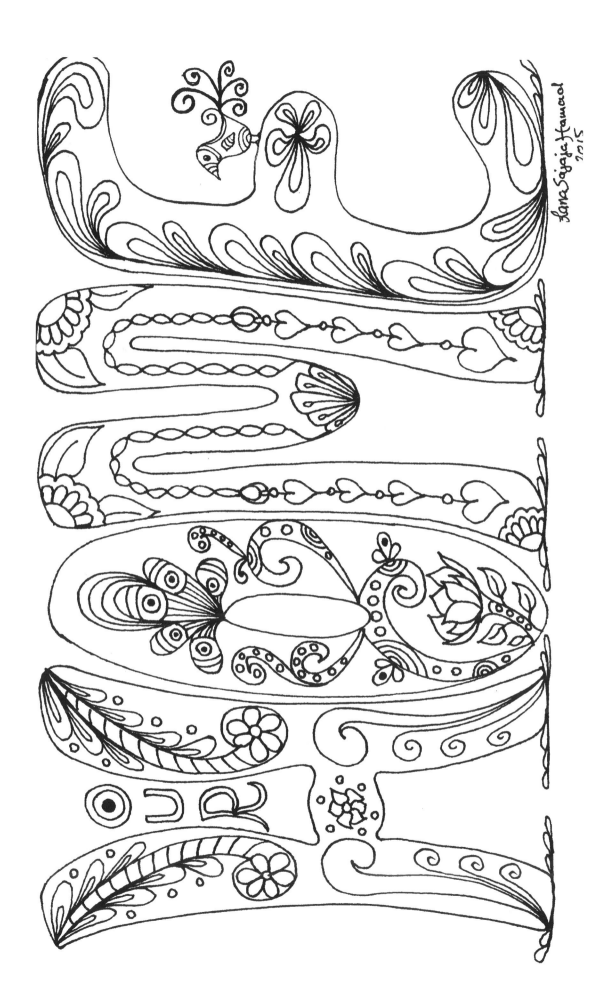

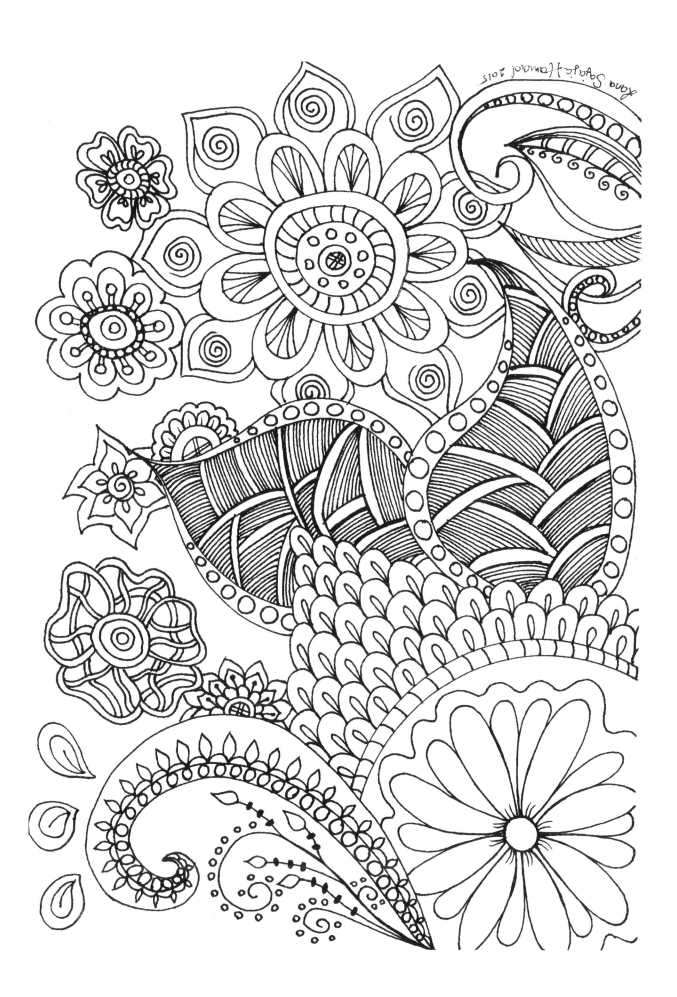

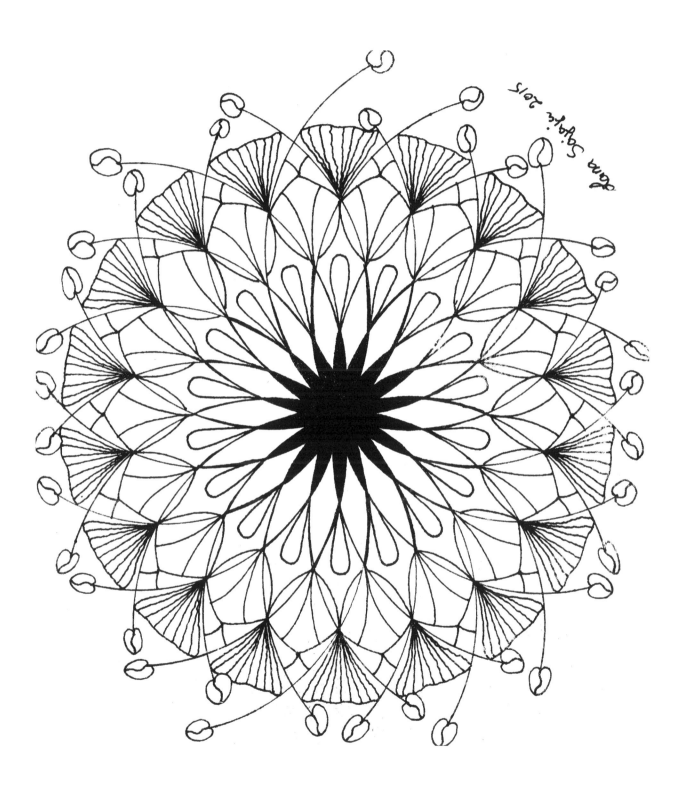

Gina Sayajie 2015

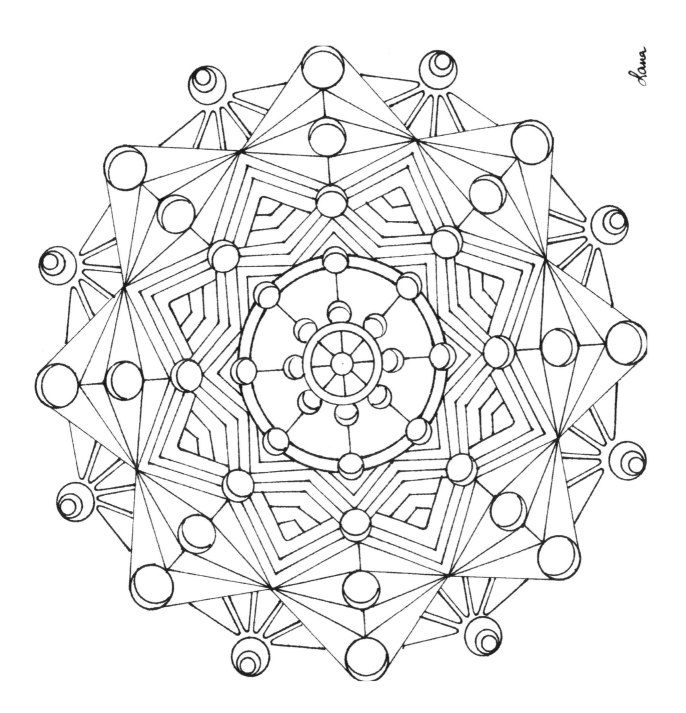

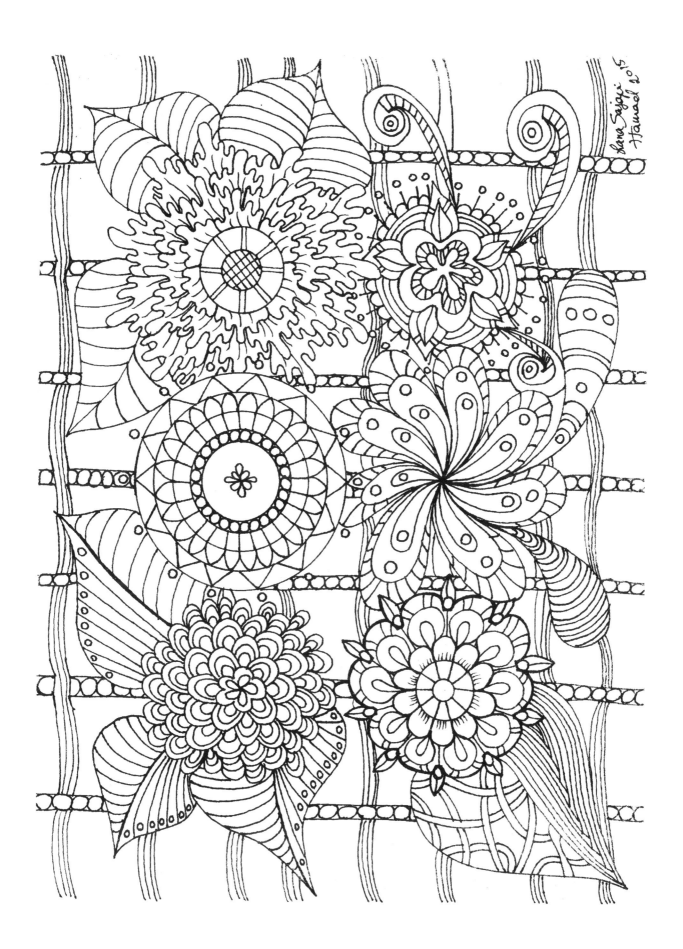

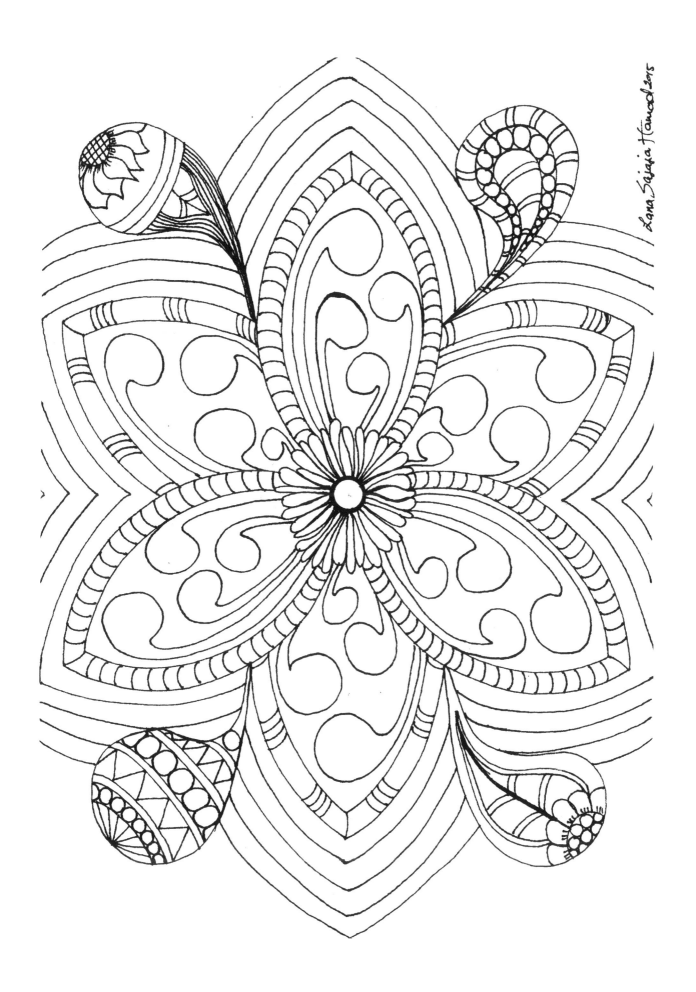

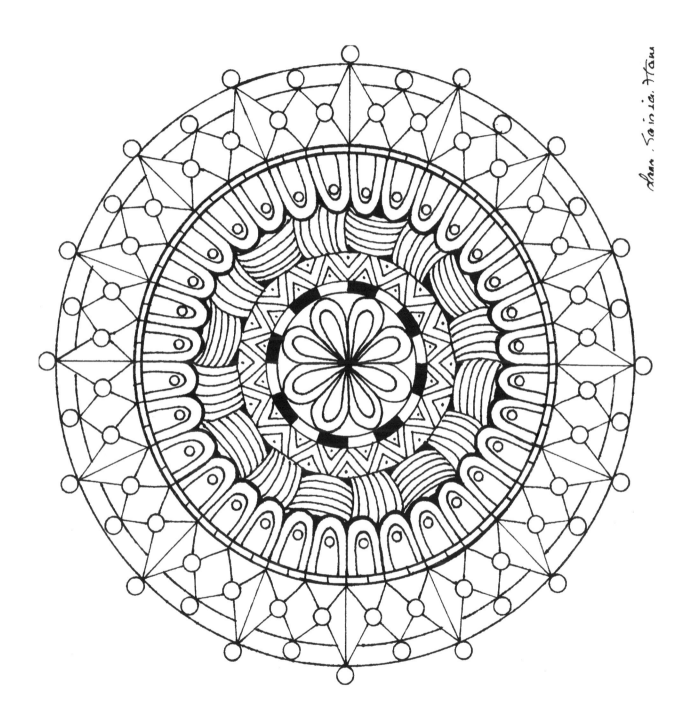

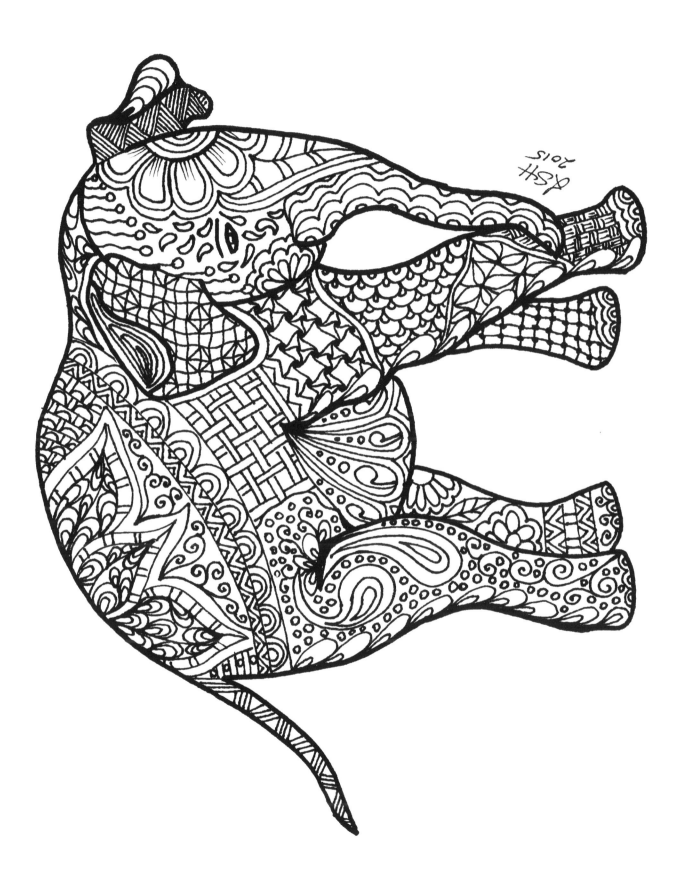

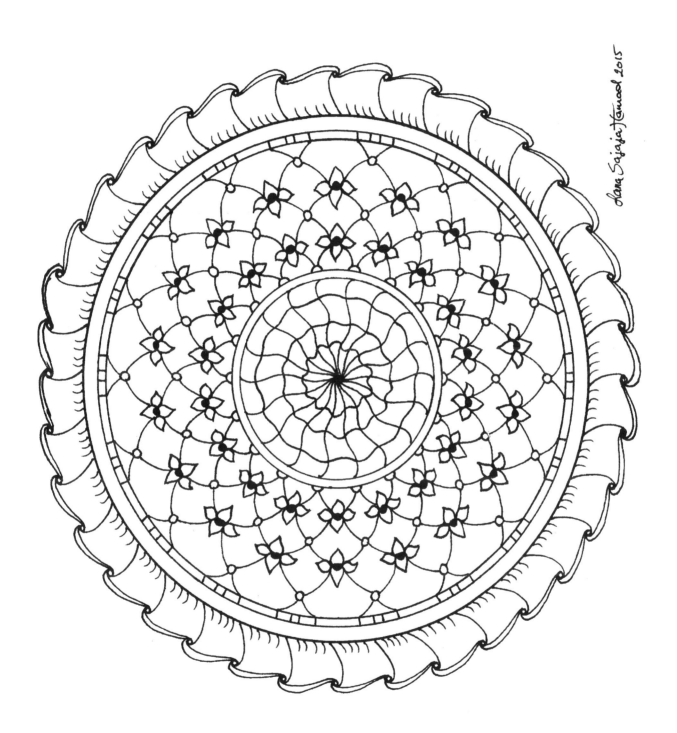

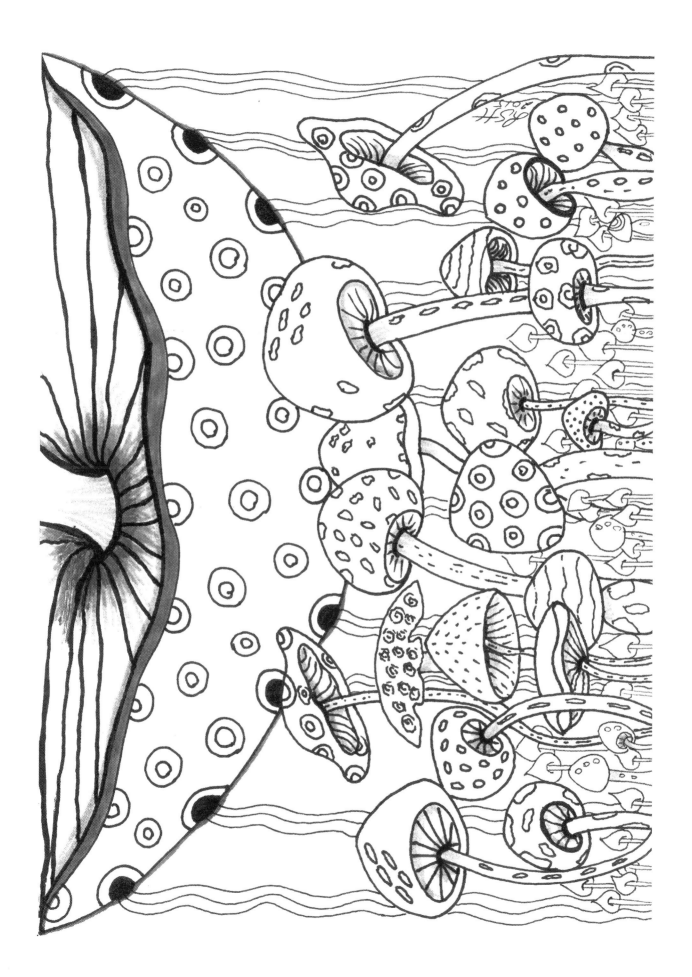

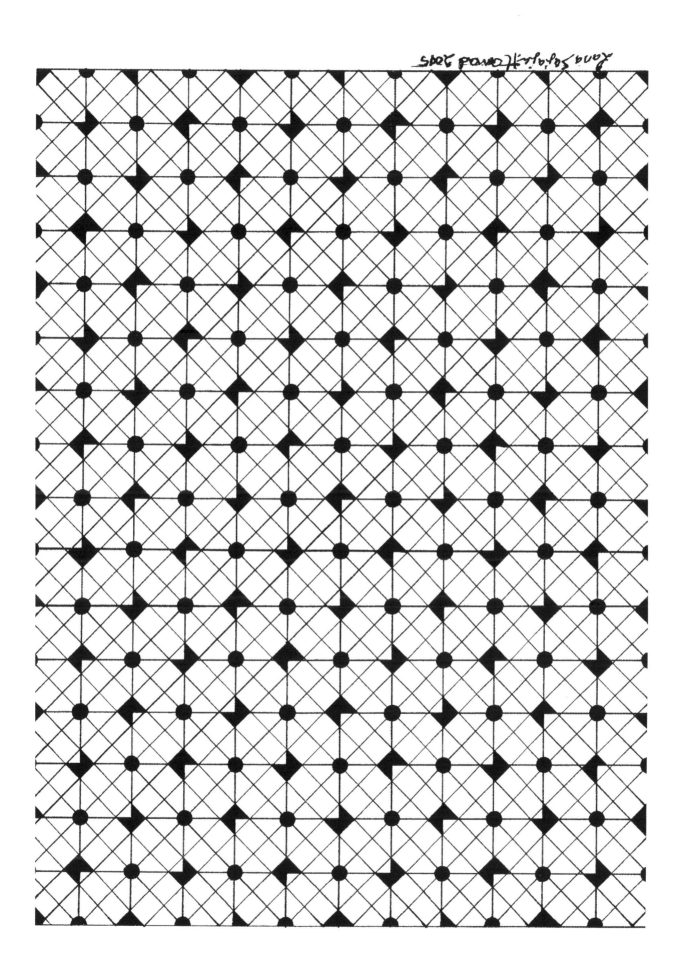

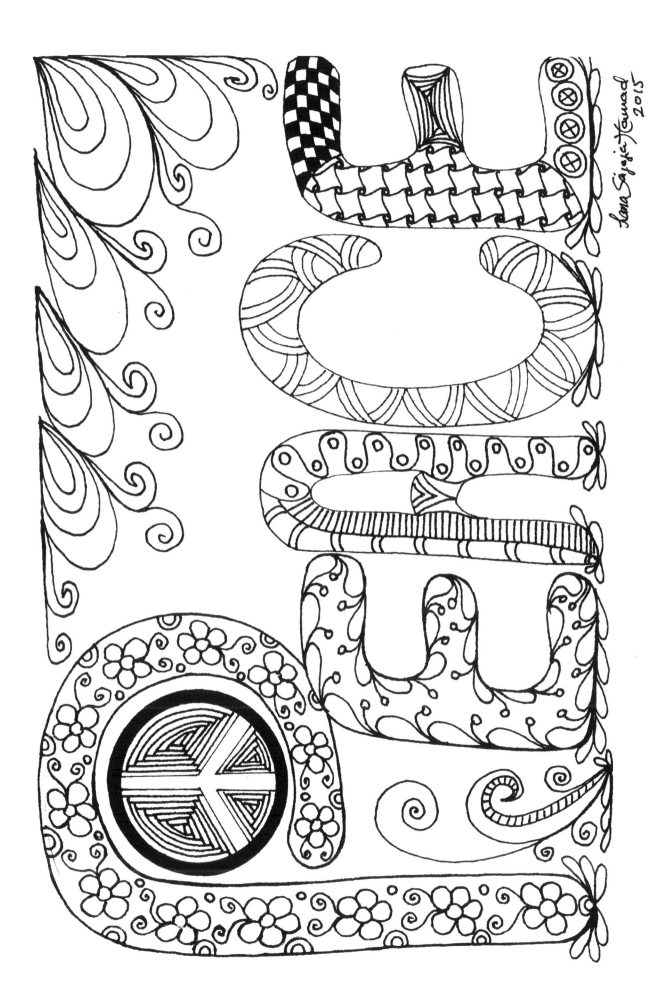

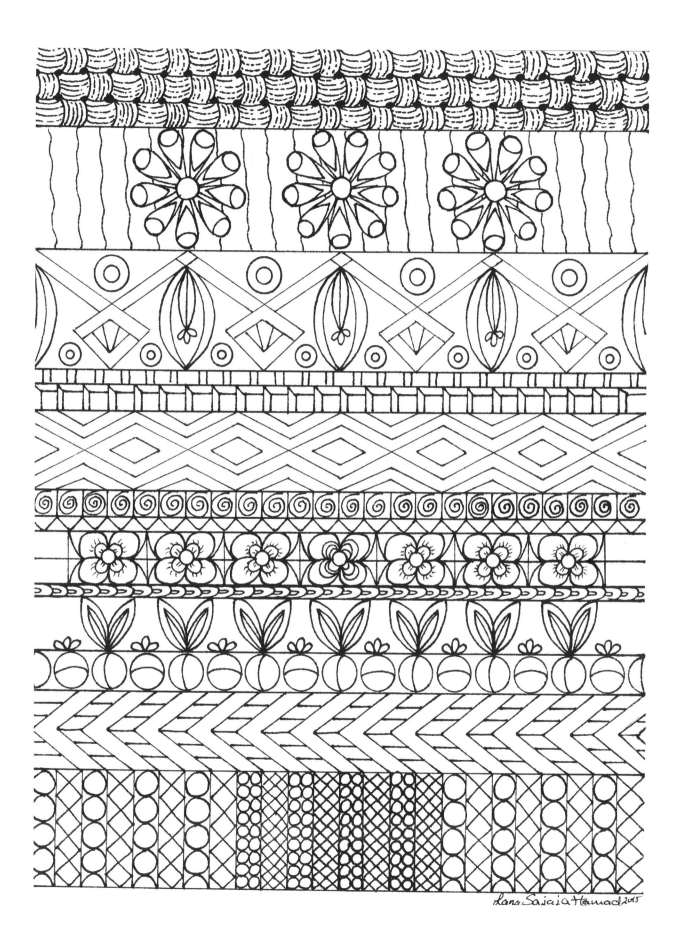

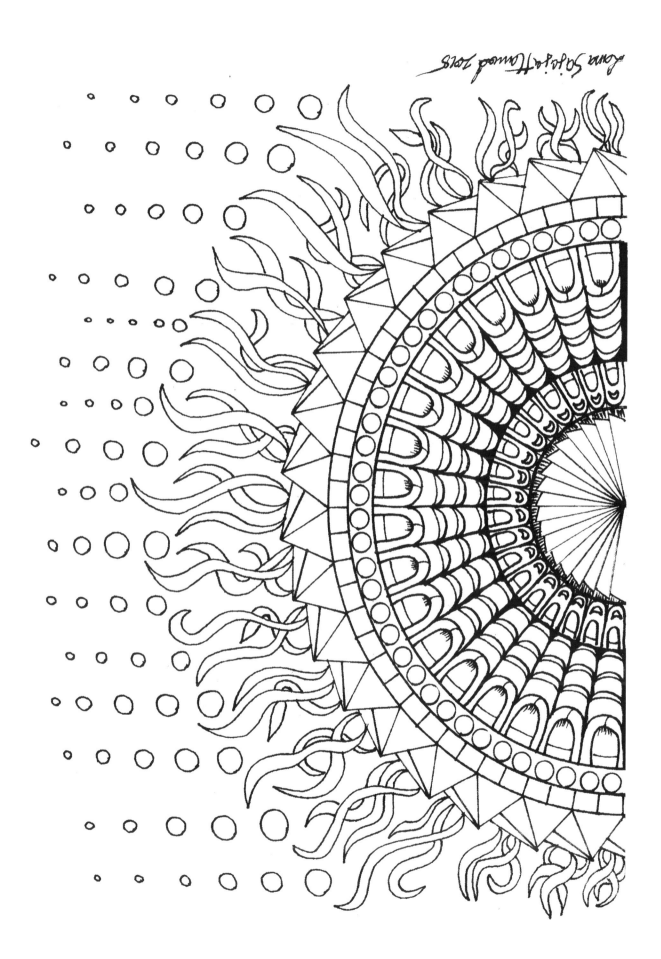

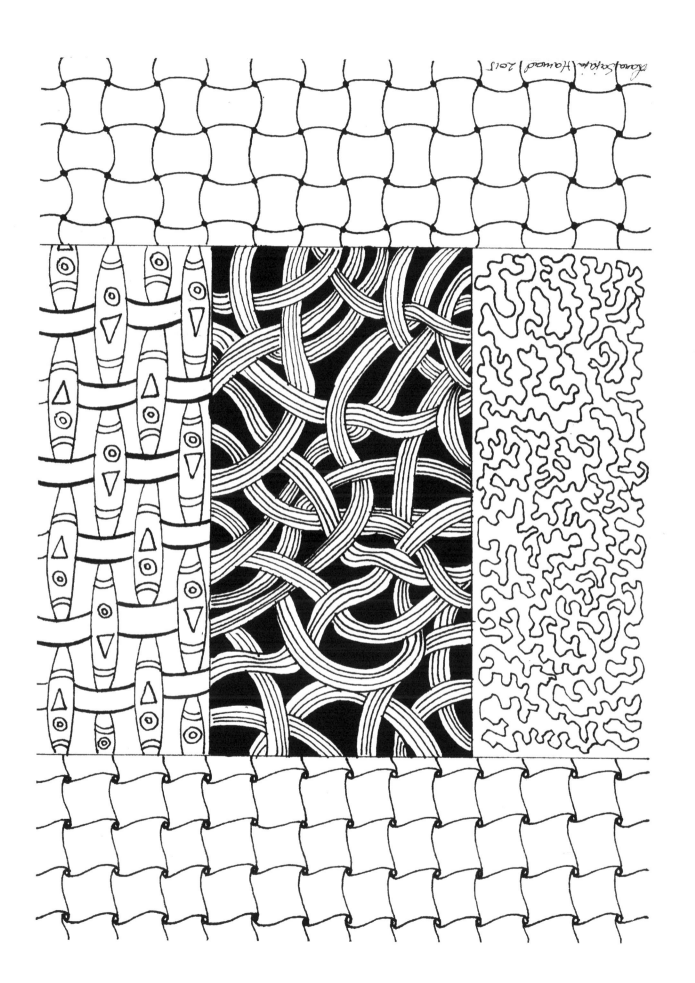

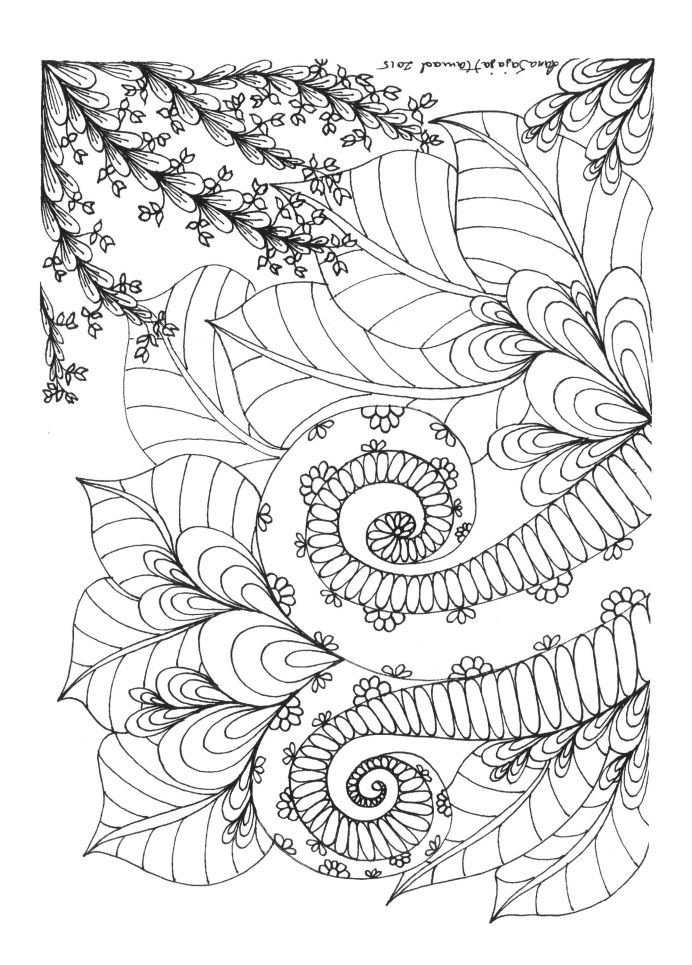

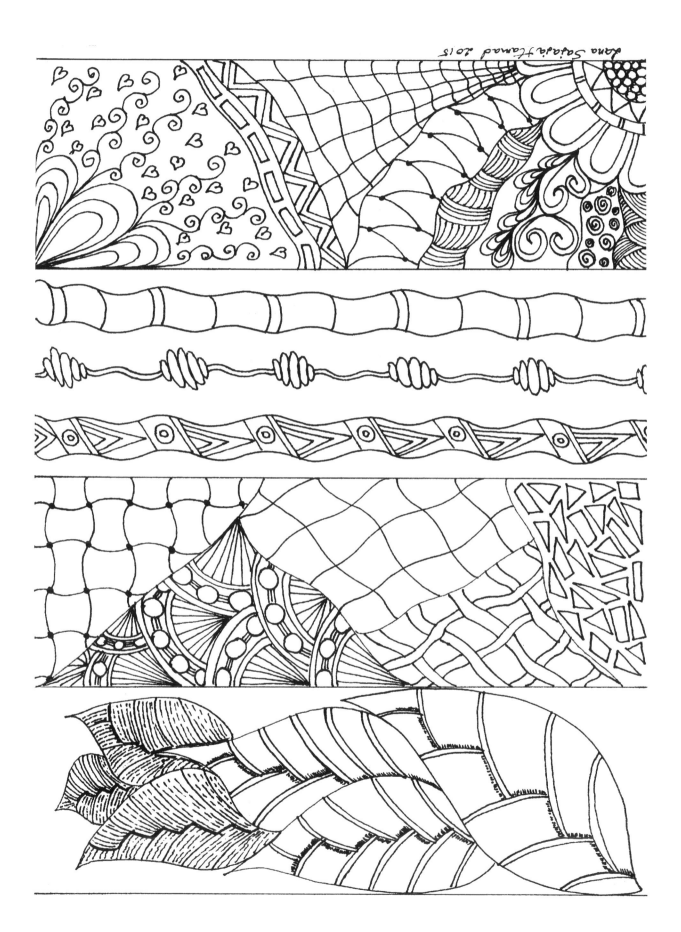

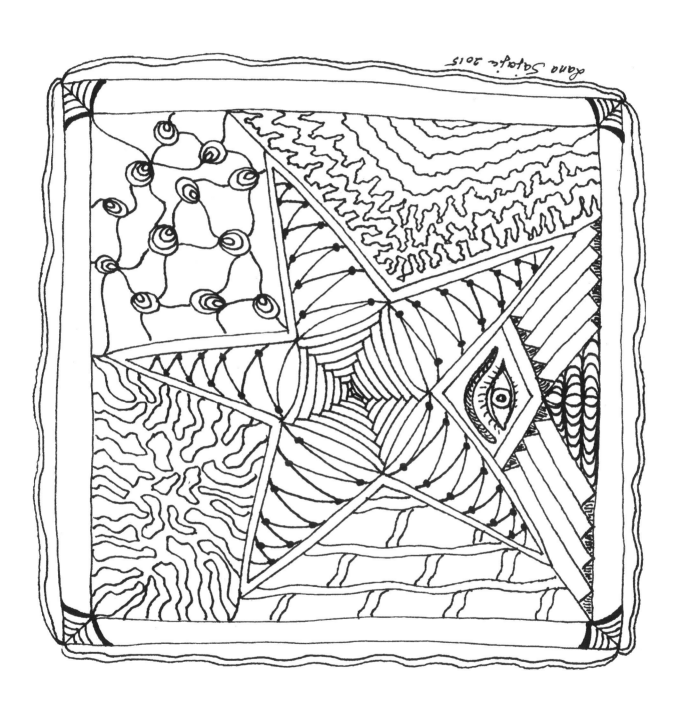

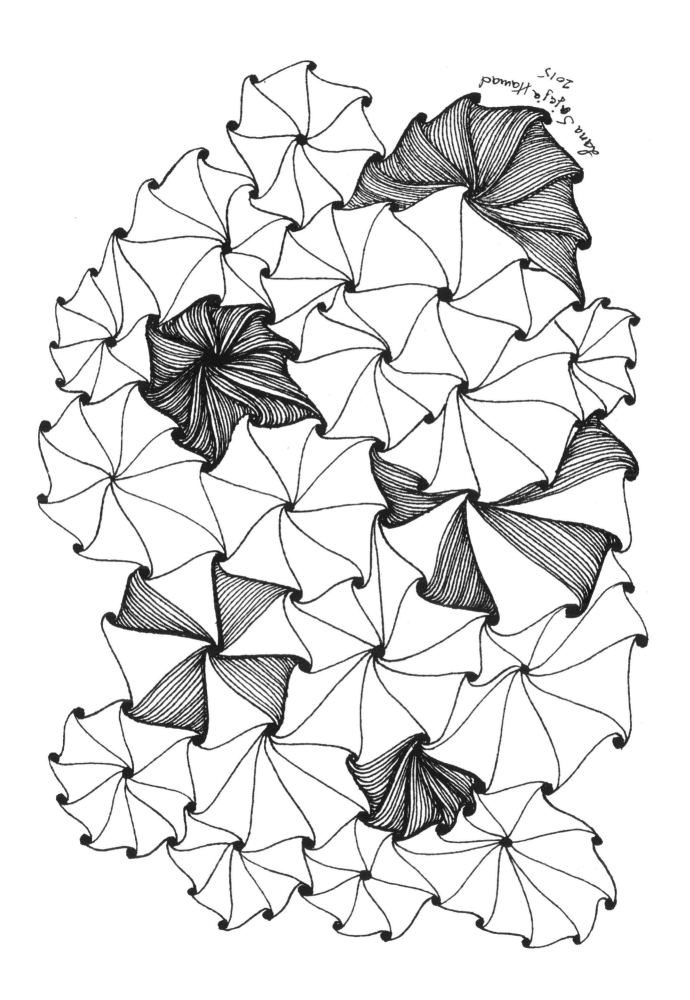

Jana Sayed Hawad
2015

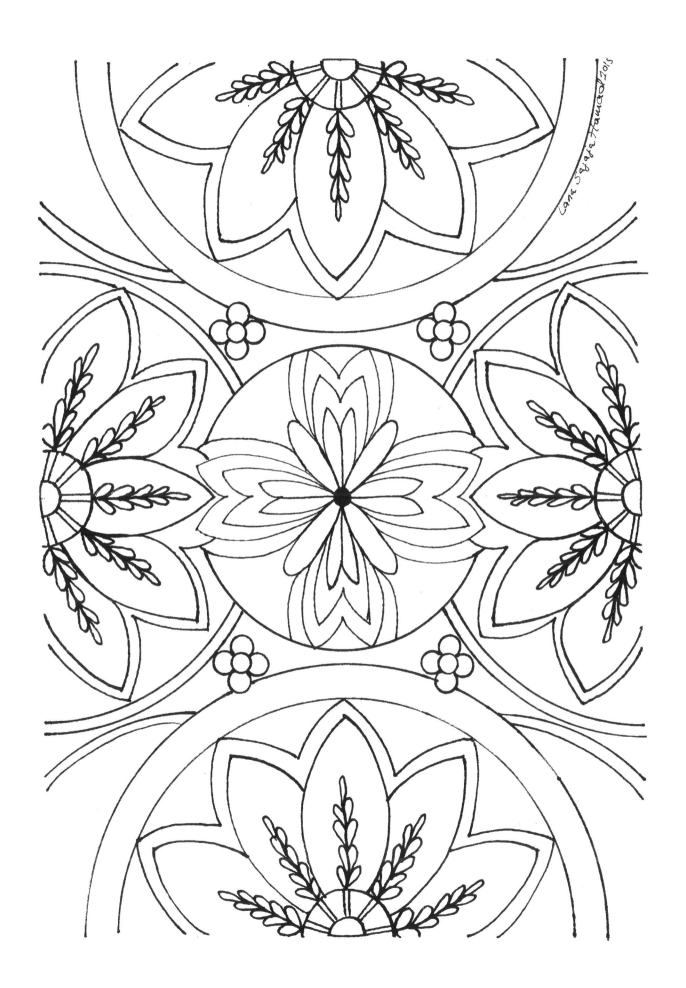

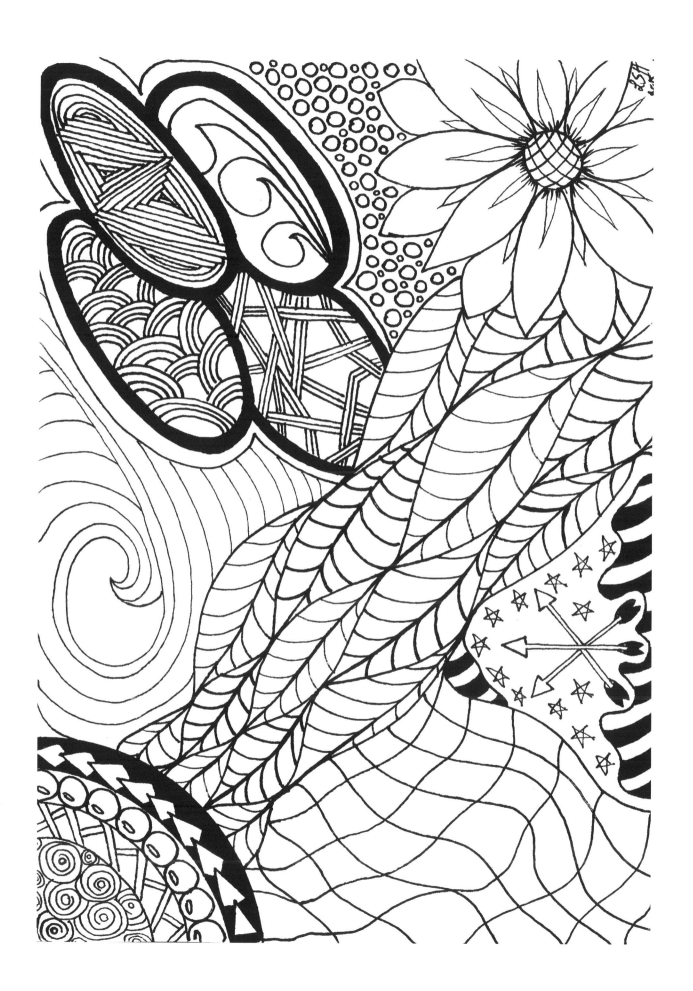

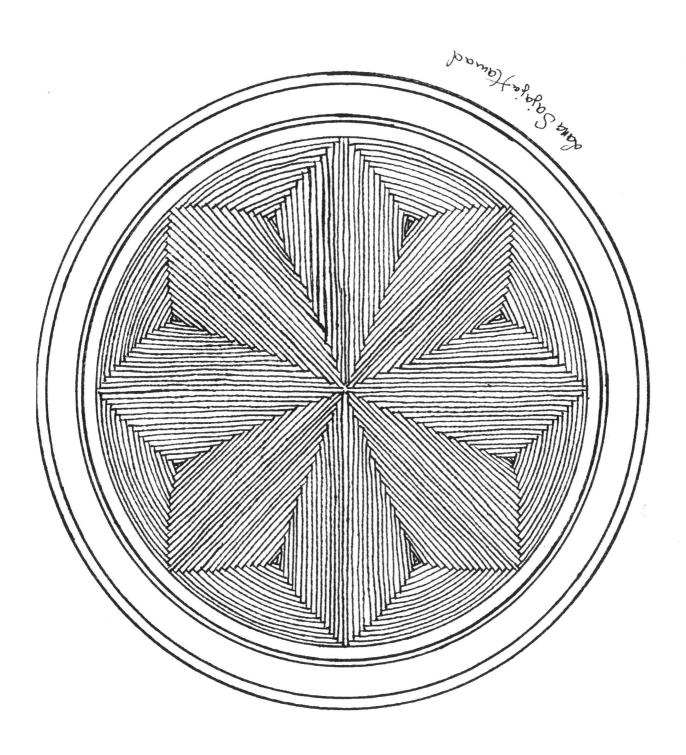

Anna Sophia Howard

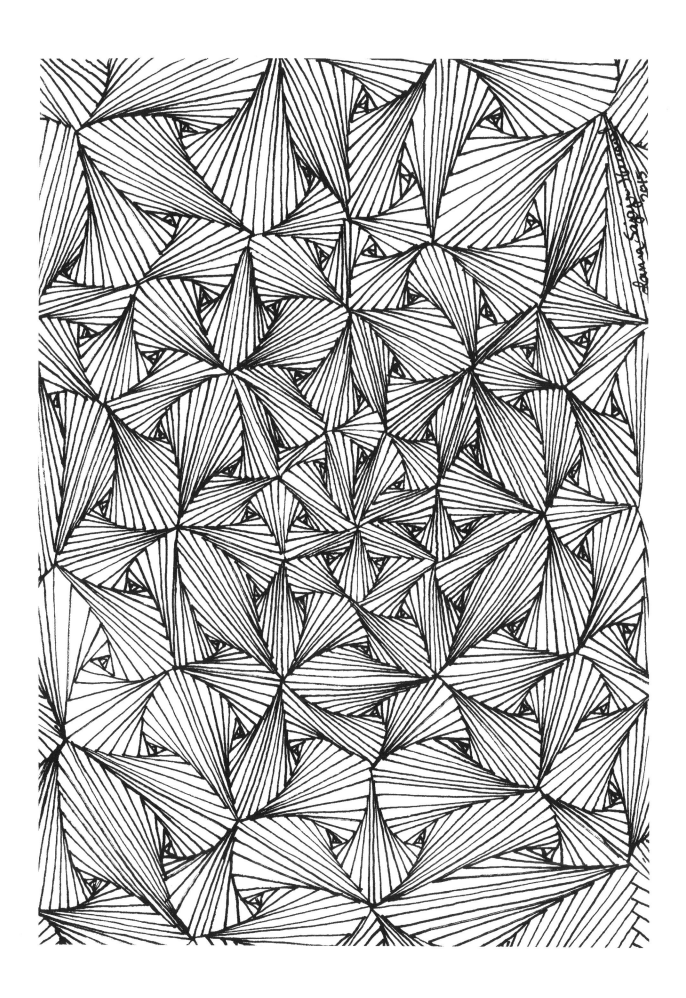

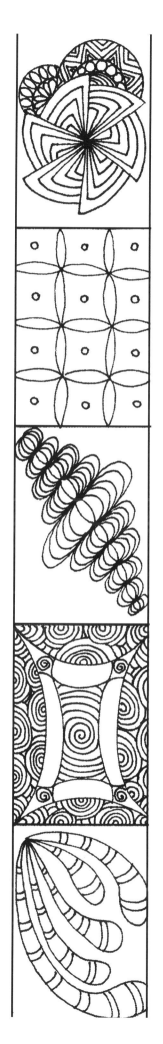

ABOUT THE AUTHOR

I am a mixed media artist, a professional crafter and a self taught doodler and tangler. Over the years I have taken many art and craft classes to improve my talent. For years my day job was teaching and selling my arts and crafts.

About a couple of years ago I went back to basic drawing and doodling and rediscovered the relaxing and healing effect of it. It was the most effective way to ease my daily stress and help me unwind, I started selling individual drawings to my friends and family then decided to make a coloring book that will have a big collection of my drawings and would also help other people unwind.

I also love painting, organic gardening, crocheting, stitching and cooking new recipes for my family.

And now I'm very pleased to introduce to you my first coloring book, filled with a variety of beautiful drawings. Have fun, have fun, have fun don't stress out and I hope each and every drawing brings a smile to your face. Remember—smiles make the world a better place and lift your spirit. Enjoy!